Paws

THIS BOOK WILL HELP YOU

TAKE A BREAK

ALLY FRANCIS

summersdale

PAWS

An Hachette UK Company
www.hachette.co.uk

Summersdale Publishers Ltd
Part of Octopus Publishing Group Limited
Carmelite House
50 Victoria Embankment
LONDON
EC4Y 0DZ
UK

www.summersdale.com

Printed and bound in China

ISBN: 978-1-78783-002-8

Substantial discounts on bulk quantities of Summersdale books are available to corporations, professional associations and other organizations. For details contact general enquiries: telephone: +44 (0) 1243 771107 or email: enquiries@summersdale.com.

To.................................

From.............................

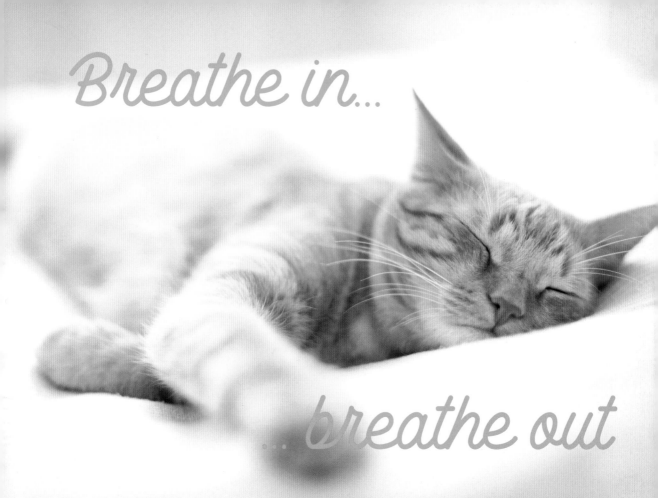

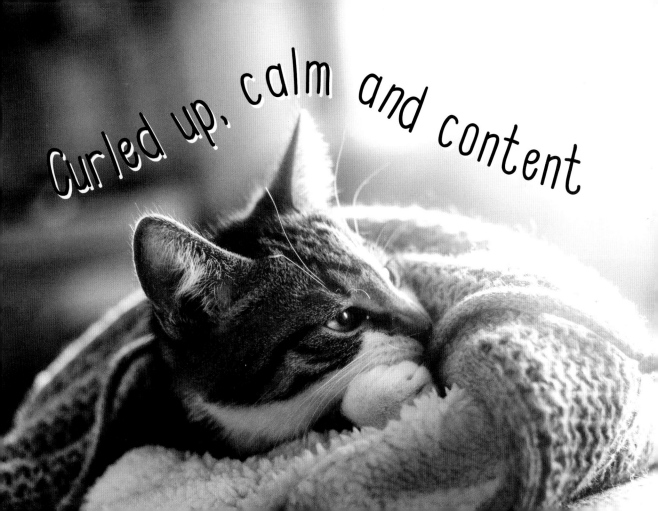

Curled up, calm and content

Cats are

CONNOISSEURS

of

COMFORT.

JAMES HERRIOT

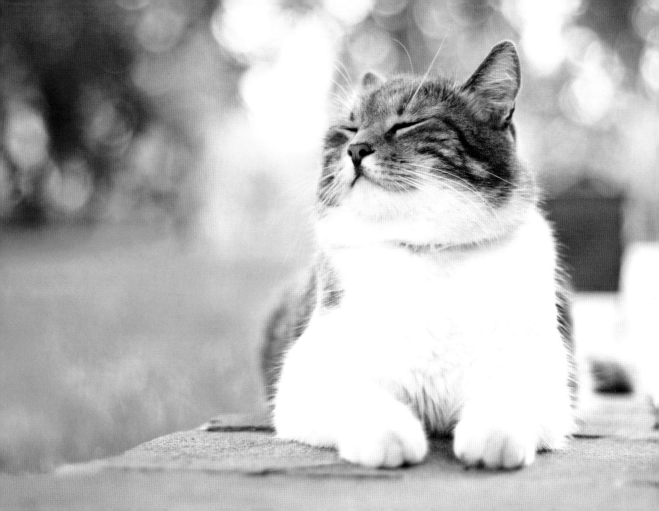

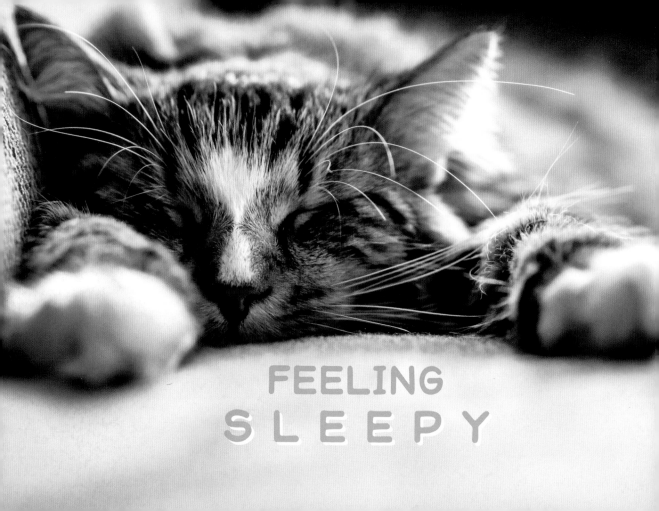

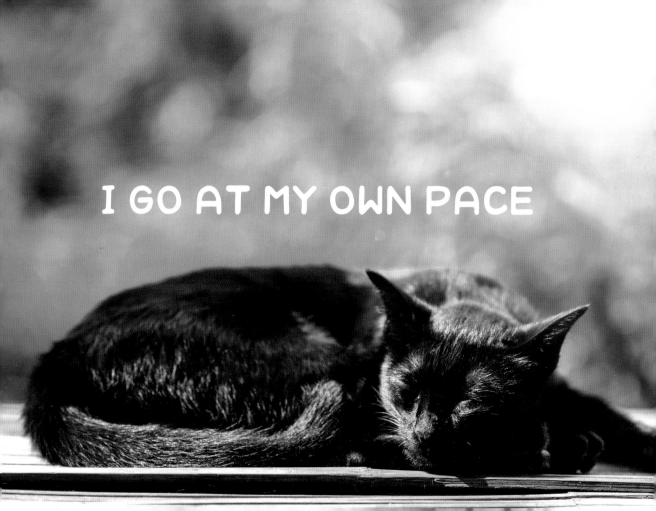

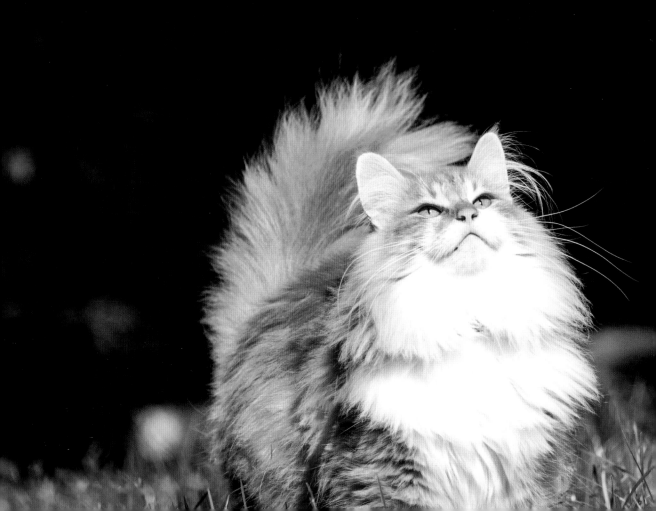

Smile, breathe and go slowly.

THÍCH NHẤT HANH

A SILENCE WITH YOU IS NOT A SILENCE, BUT A MOMENT RICH WITH PEACE.

LEONARD NIMOY

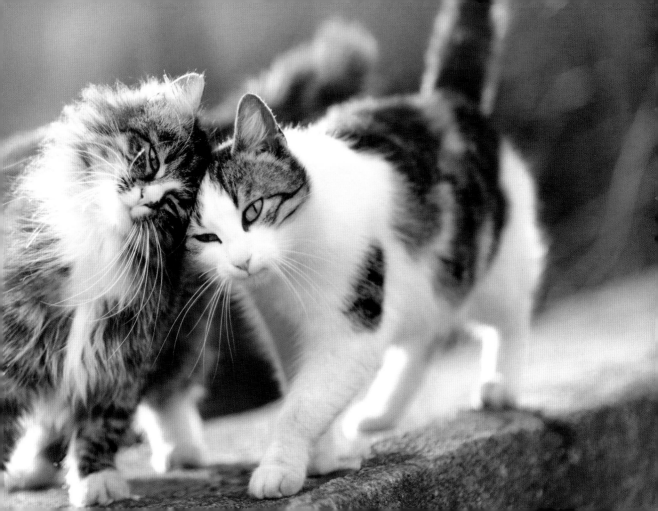

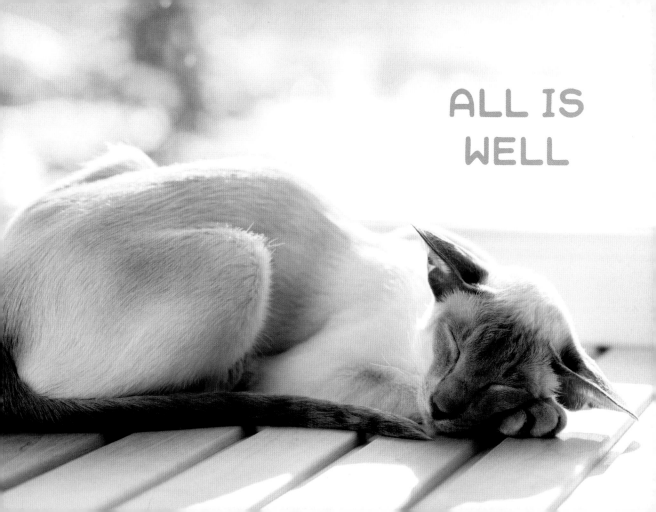

ALL IS
WELL

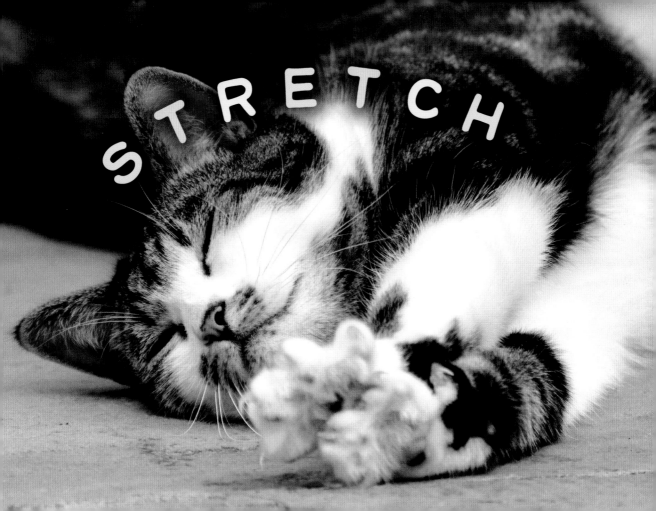

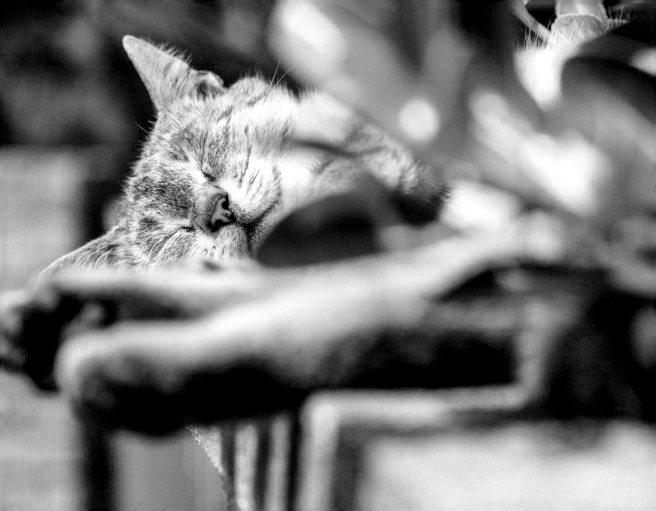

NOTHING CAN

BRING YOU

peace

BUT YOURSELF.

RALPH WALDO EMERSON

YOU ARE YOUR BEST THING.

TONI MORRISON

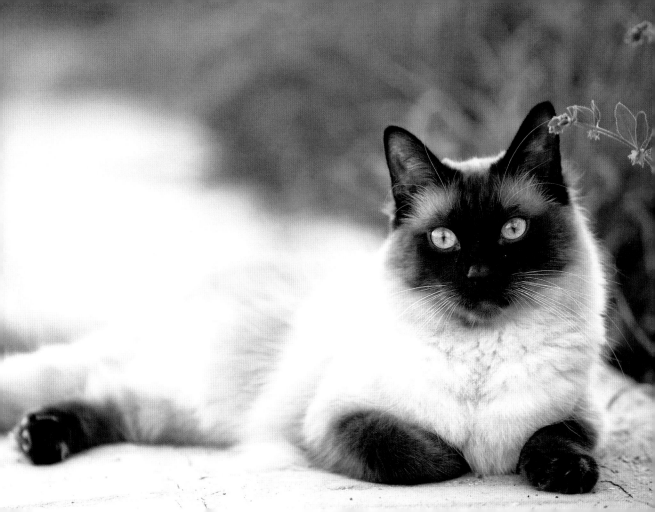

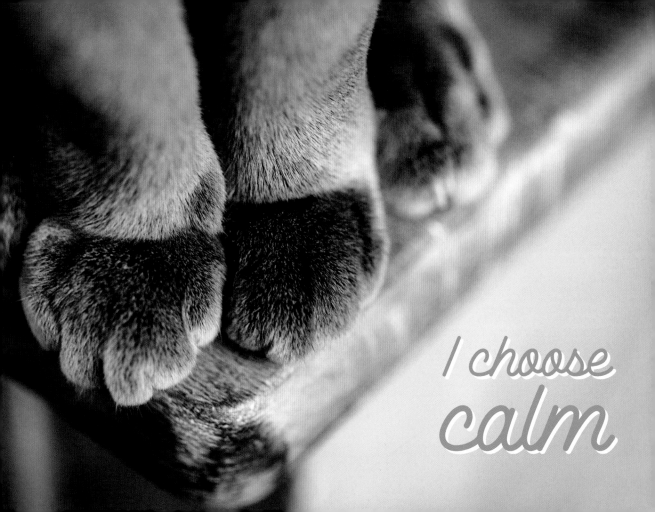

I choose
calm

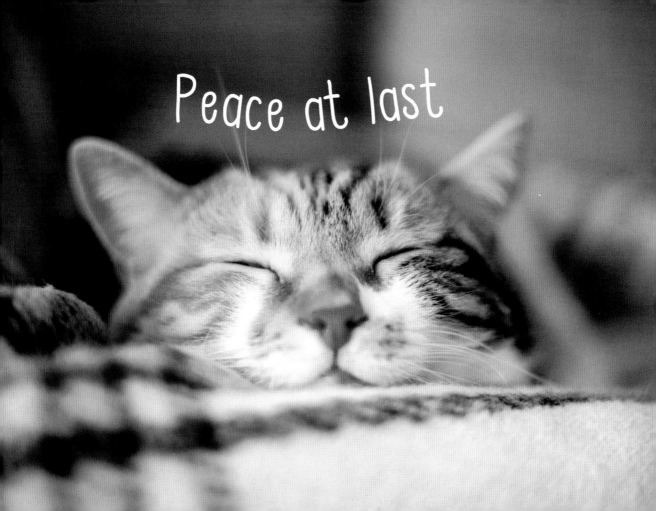
Peace at last

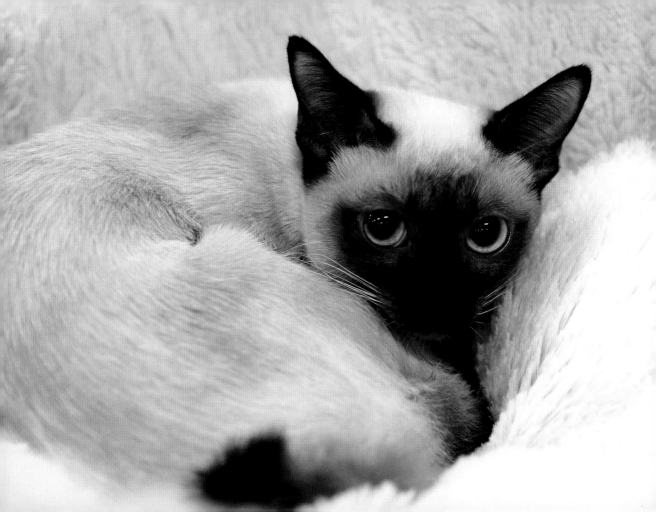

I am a
BETTER PERSON
when I have
LESS ON MY PLATE.

ELIZABETH GILBERT

OUR GREATEST EXPERIENCES
ARE OUR QUIET MOMENTS.

FRIEDRICH NIETZSCHE

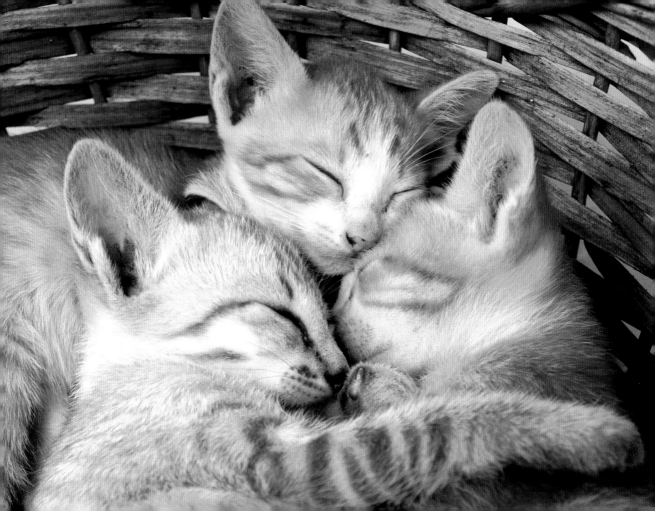

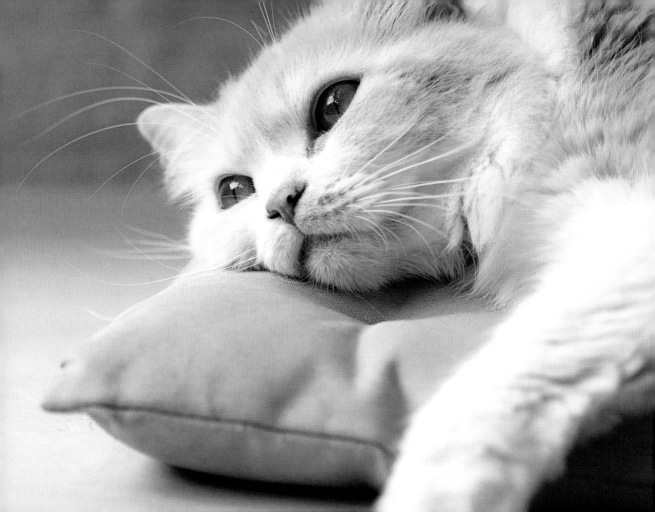

I have studied
many philosophers
AND MANY CATS.
The wisdom of cats is
INFINITELY SUPERIOR.

HIPPOLYTE TAINE

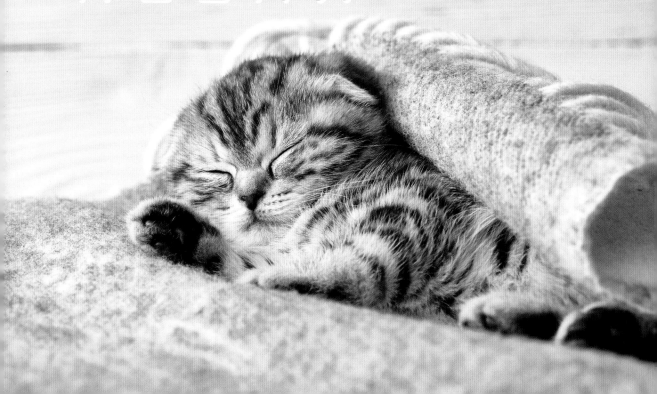

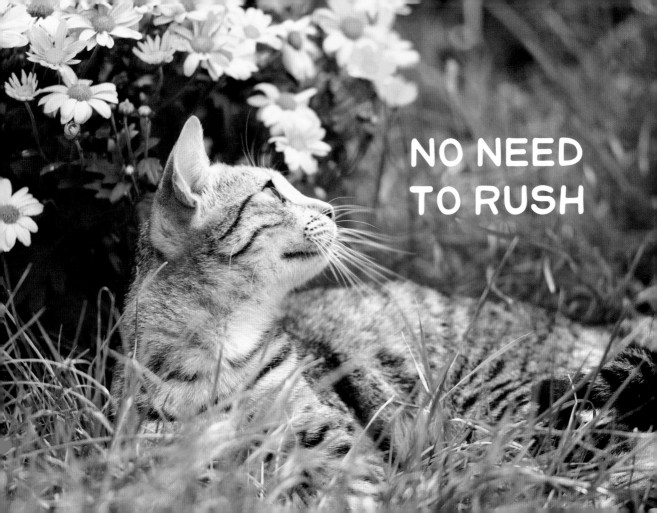

WITHIN YOU THERE IS
A STILLNESS AND A
SANCTUARY TO WHICH
YOU CAN RETREAT
AT ANY TIME AND
BE YOURSELF.

HERMANN HESSE

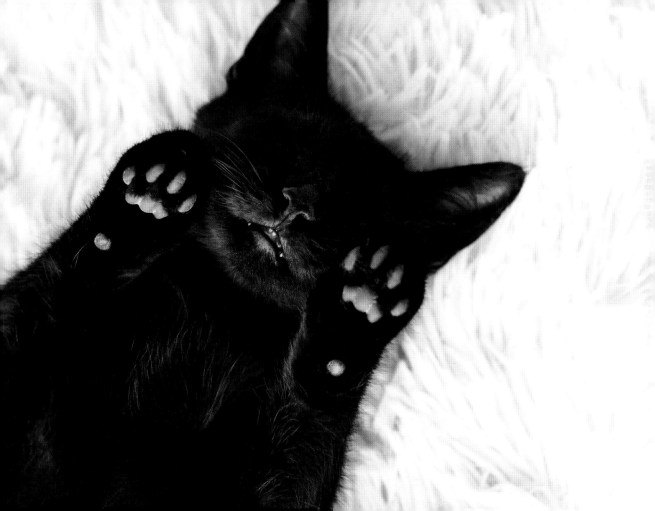

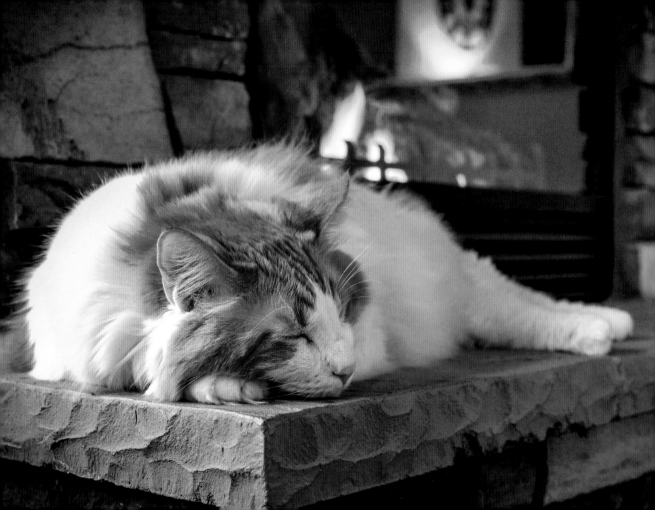

CATS AT FIRESIDES

LIVE LUXURIOUSLY

AND ARE THE

picture of comfort.

LEIGH HUNT

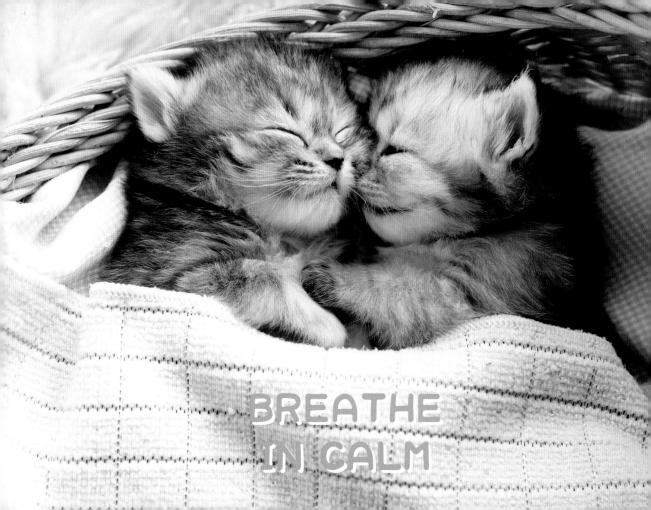

BREATHE
IN CALM

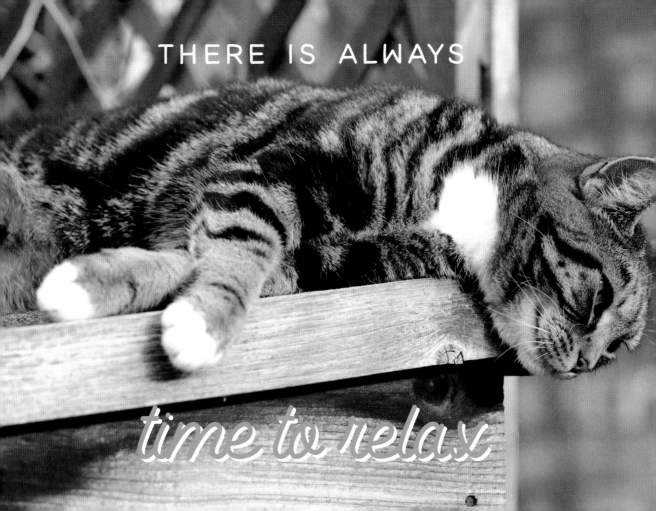

I have lived with
several Zen masters –
ALL OF THEM CATS.

ECKHART TOLLE

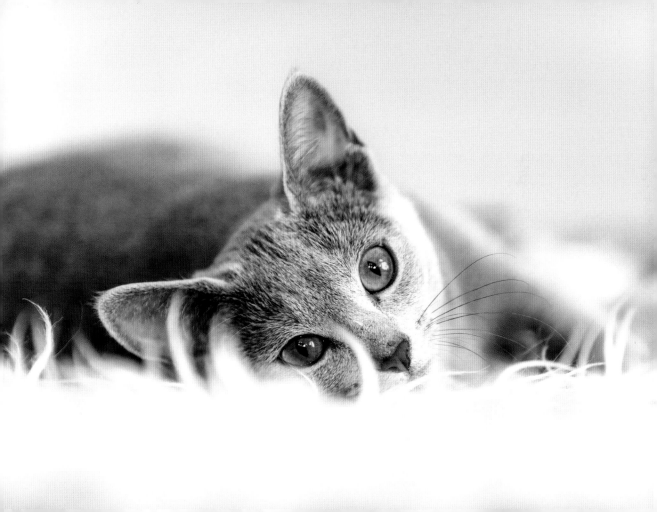

TO THE MIND THAT IS STILL,
THE WHOLE UNIVERSE
SURRENDERS.

LAO TZU

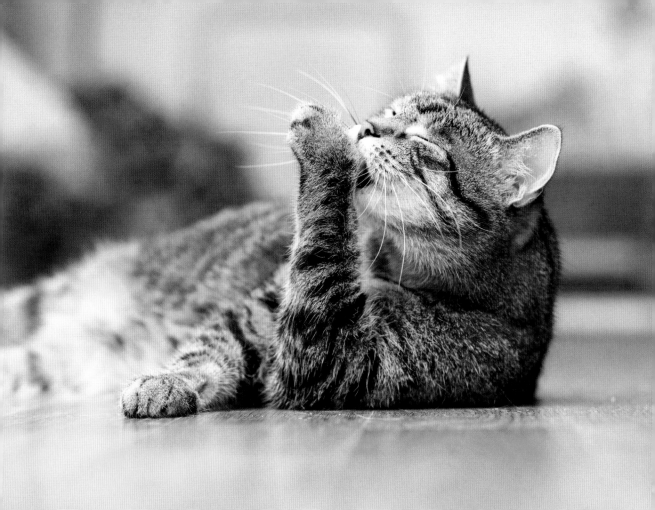

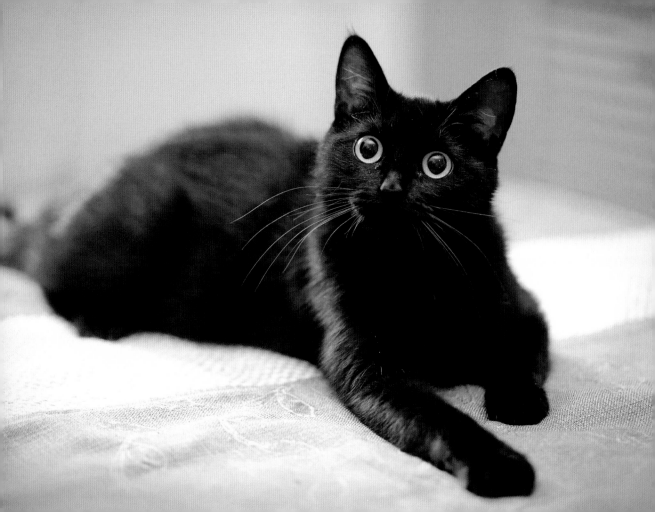

Remain calm in

EVERY SITUATION

because

PEACE EQUALS POWER.

JOYCE MEYER

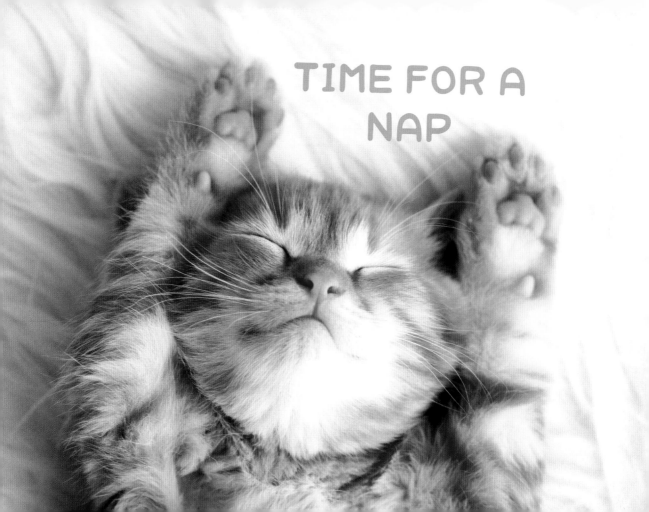

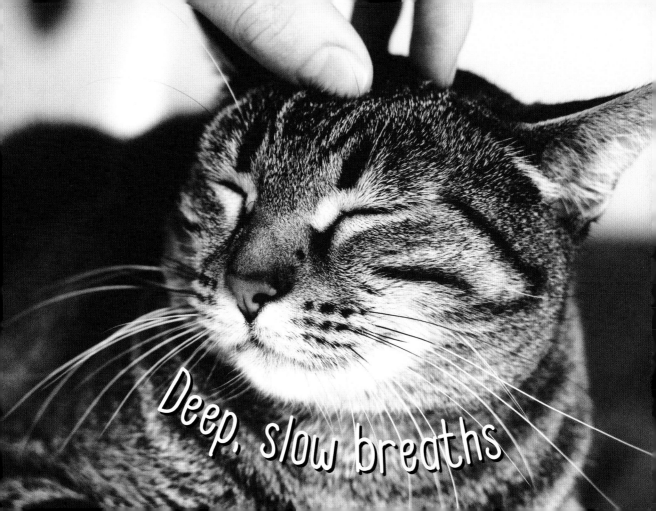

Deep, slow breaths

THE TIME TO RELAX IS WHEN YOU DON'T HAVE TIME FOR IT.

SYDNEY J. HARRIS

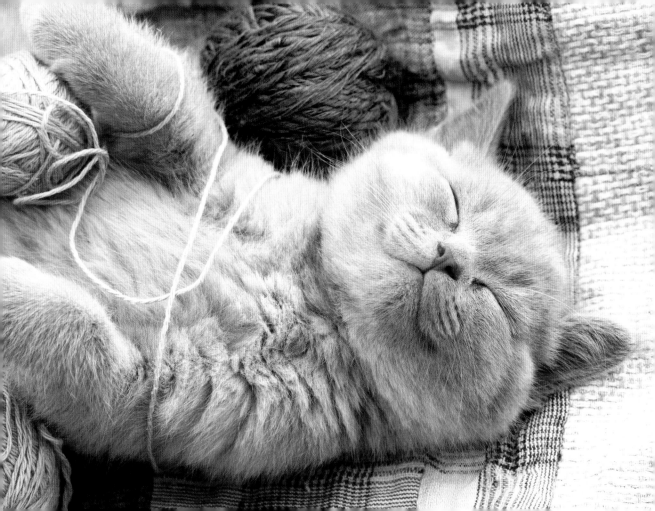

EACH PERSON DESERVES
A DAY... IN WHICH

no problems

ARE CONFRONTED,
NO SOLUTIONS SEARCHED FOR.

MAYA ANGELOU

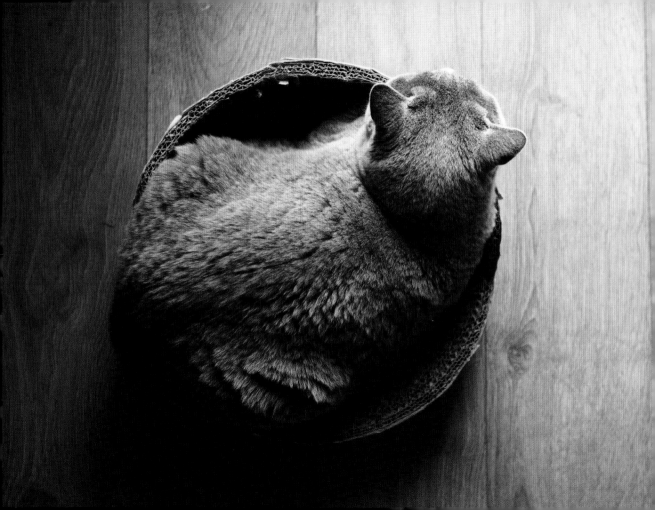

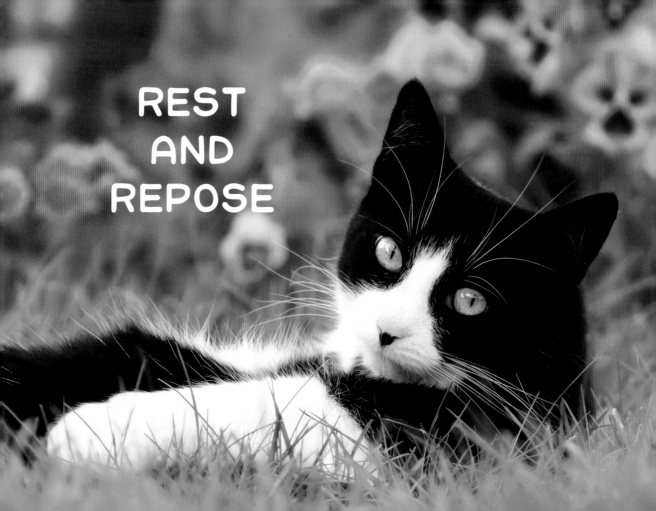

REST
AND
REPOSE

I AM

at ease

Stop a moment,
cease your work,
LOOK AROUND YOU.

LEO TOLSTOY

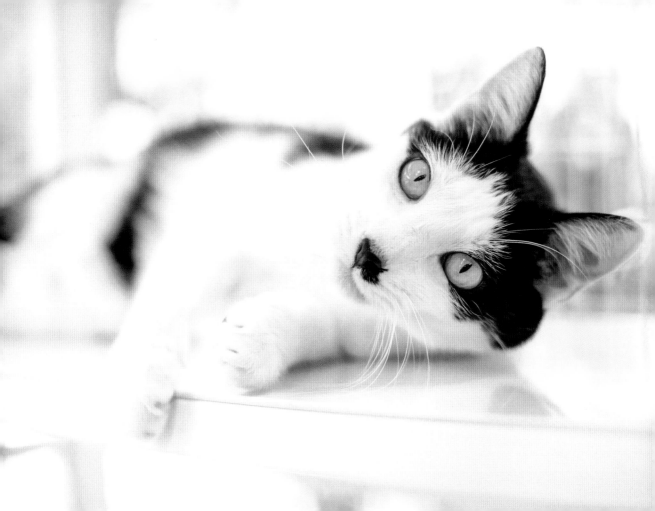

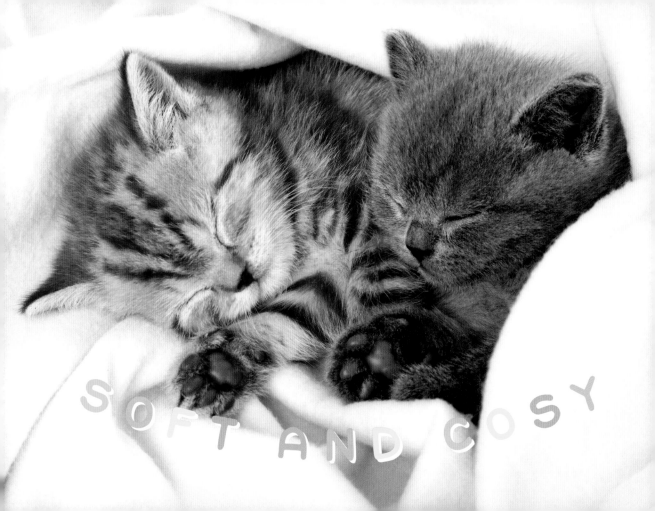

SOFT AND COSY

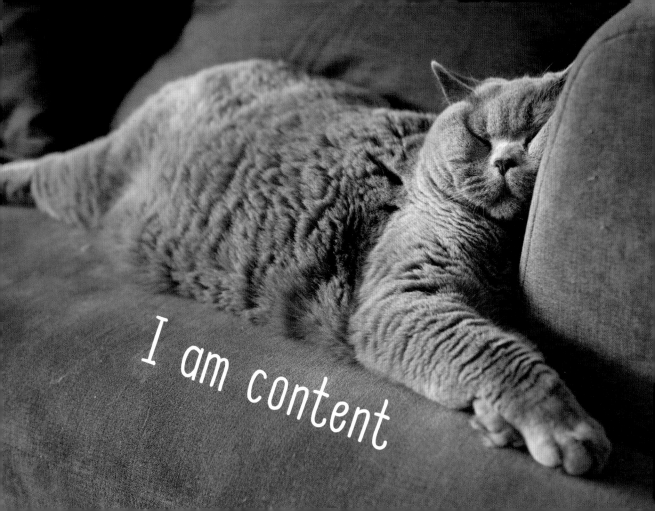

I FEEL WITHIN ME A PEACE ABOVE ALL EARTHLY DIGNITIES, A STILL AND QUIET CONSCIENCE.

WILLIAM SHAKESPEARE

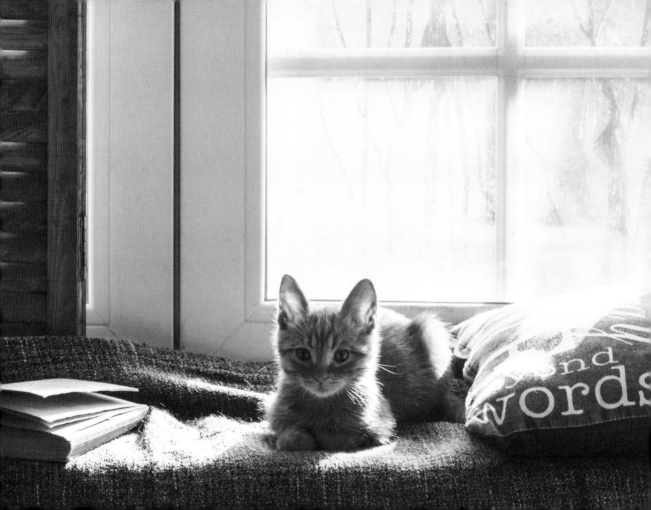

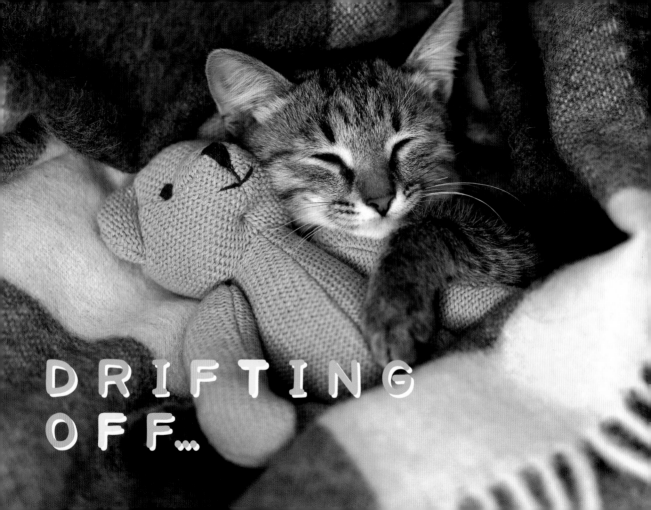

DRIFTING OFF...

Peace is within my reach

If there were to be
A UNIVERSAL SOUND
depicting peace, I would surely vote for
THE PURR.

BARBARA L. DIAMOND

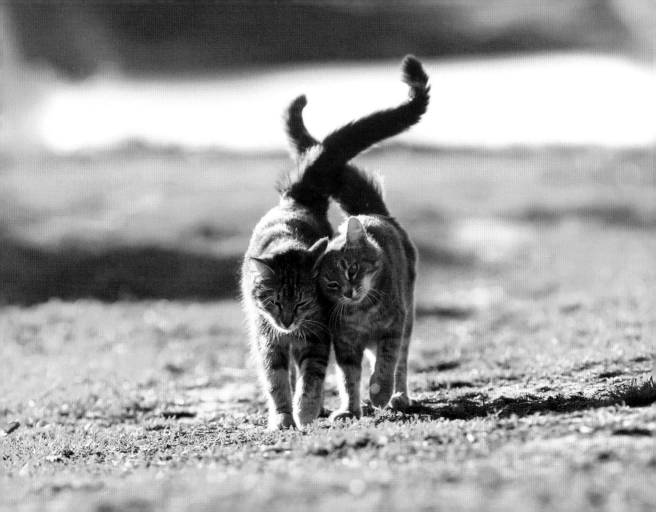

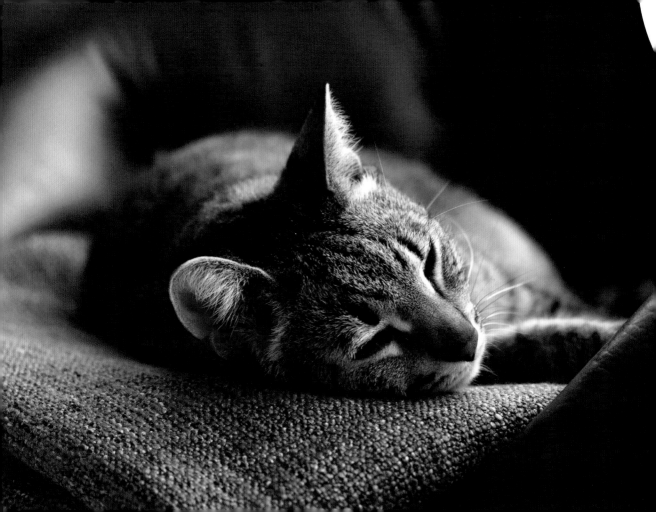

THERE ARE DAYS I DROP WORDS
OF COMFORT ON MYSELF
LIKE FALLING LEAVES AND
REMEMBER THAT IT IS
ENOUGH TO BE TAKEN
CARE OF BY MYSELF.

BRIAN ANDREAS

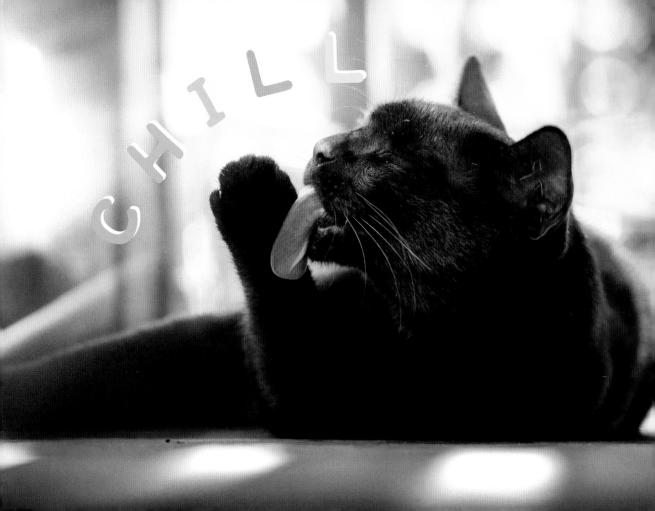

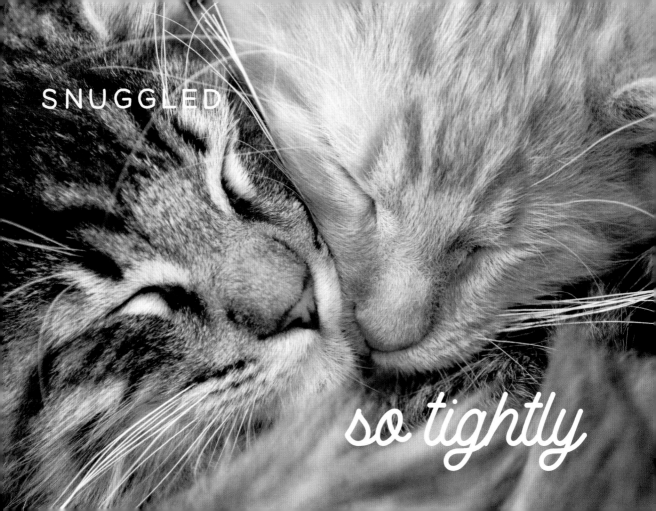

SNUGGLED

so tightly

BEING ABLE TO LET GO,
AT TIMES, IS THE

most beautiful

OF ALL!

ELIF SHAFAK

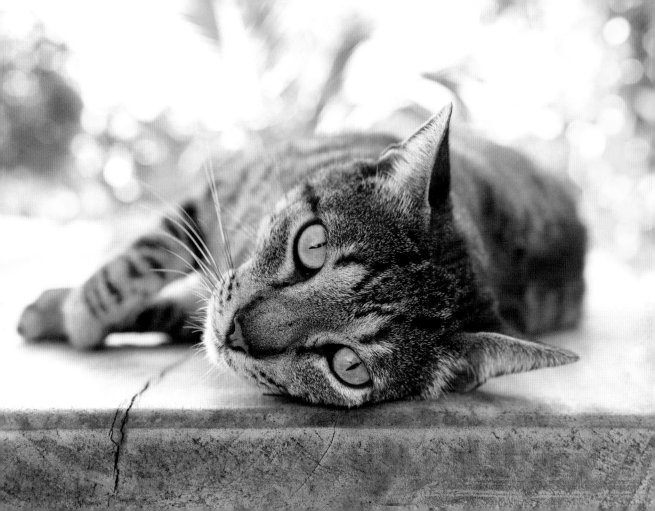

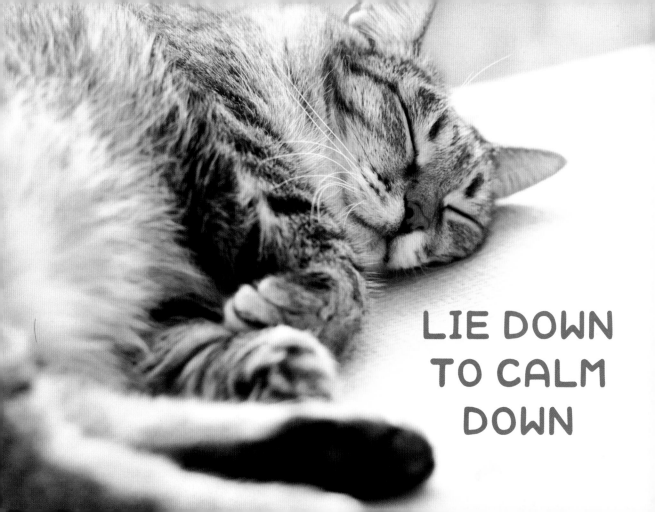
LIE DOWN TO CALM DOWN

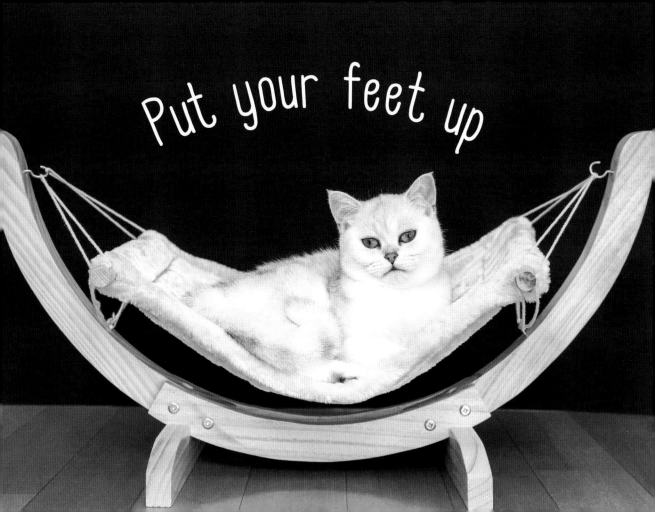

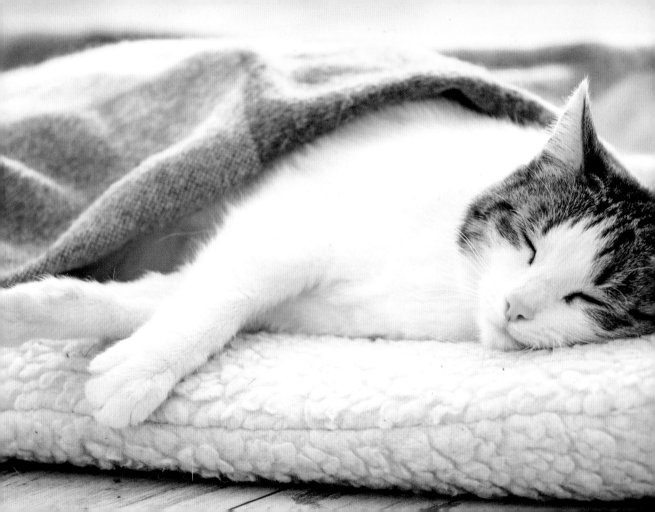

YOU CANNOT LOOK AT
A SLEEPING CAT
AND FEEL TENSE.

JANE PAULEY

Let peace be your middle name.

NTATHU ALLEN

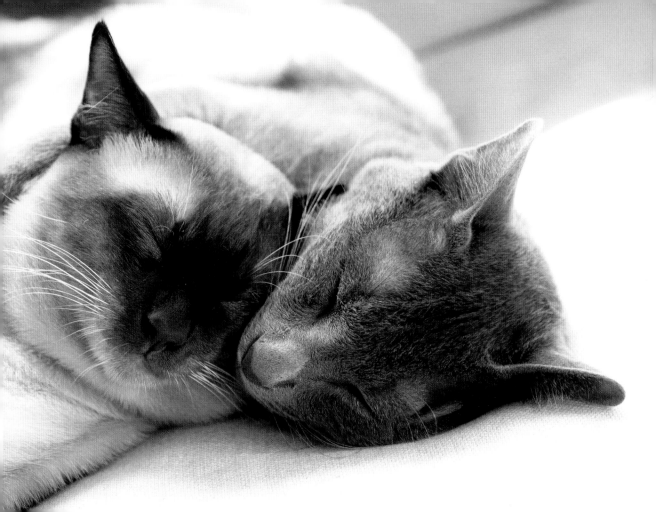

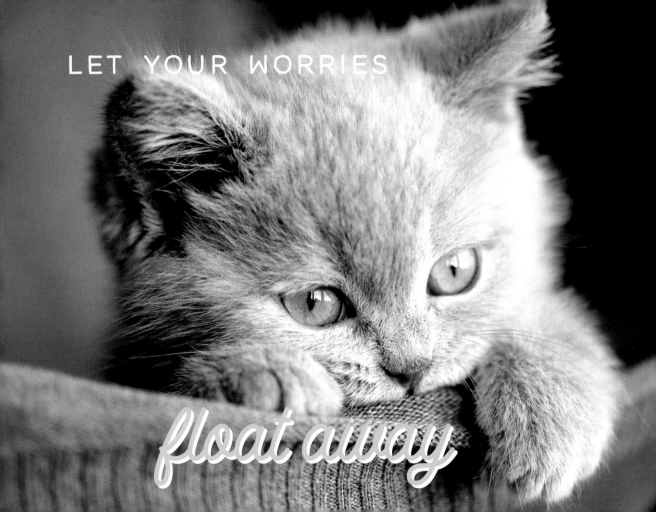

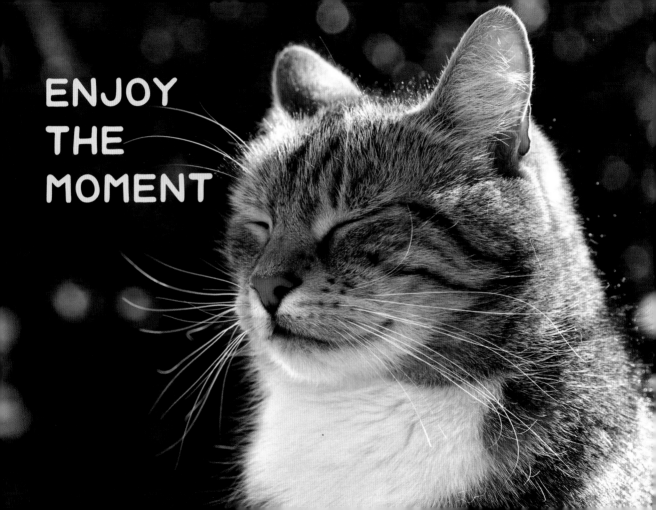

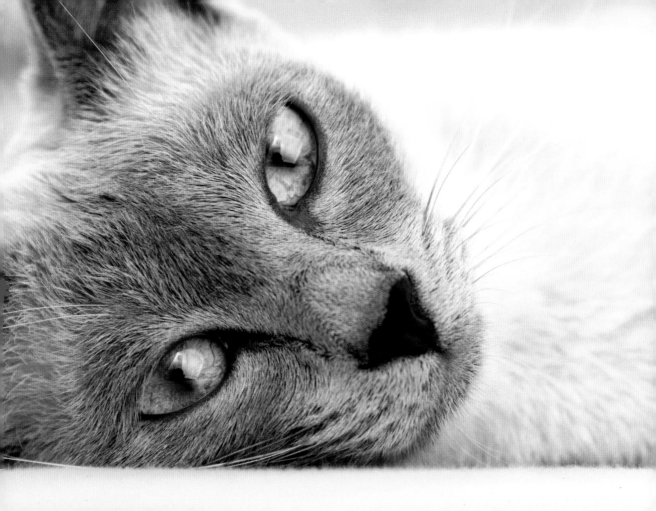

Tension is who you
think you should be.
RELAXATION IS WHO YOU ARE.

CHINESE PROVERB

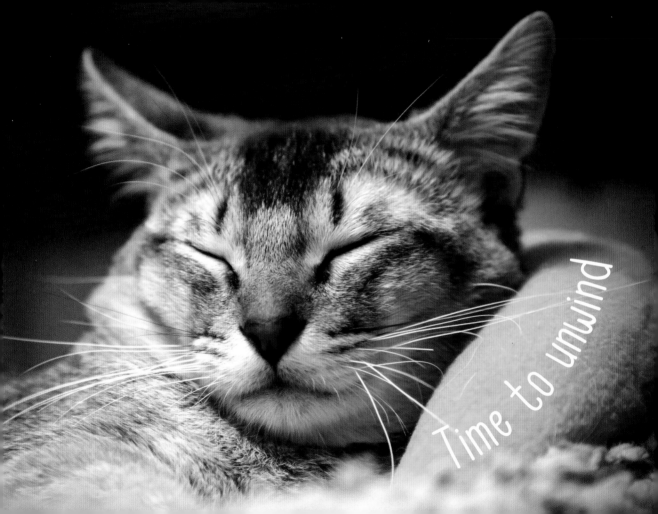

Time to unwind

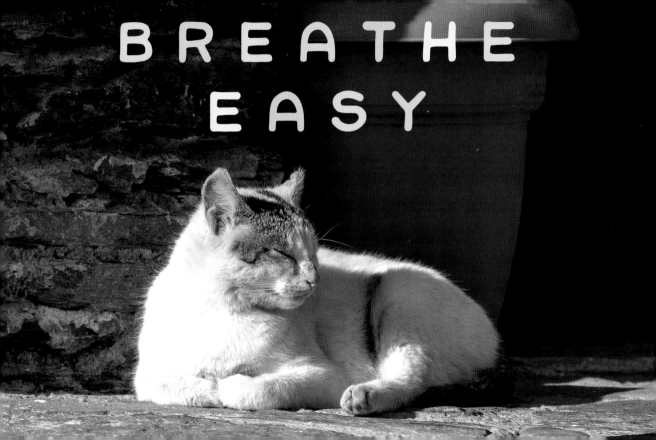

The inspiration you seek is
ALREADY WITHIN YOU.
Be silent and listen.

RUMI

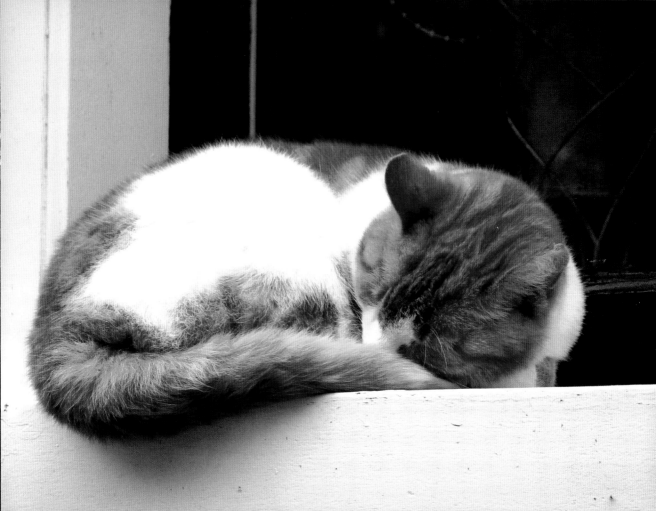

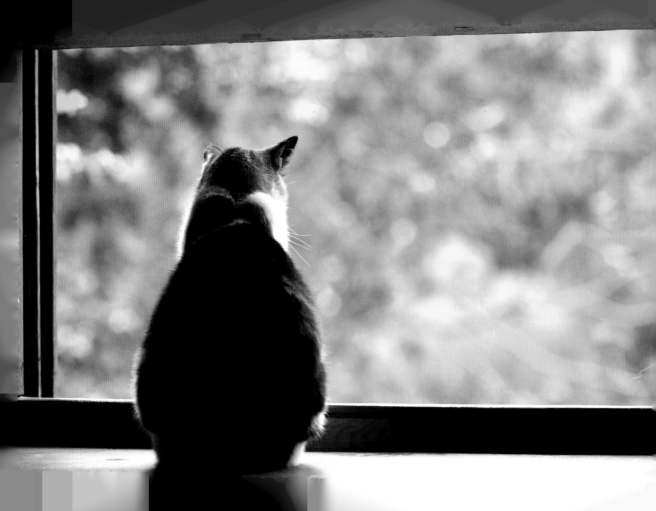

THE IDEAL OF CALM EXISTS IN A SITTING CAT.

JULES RENARD

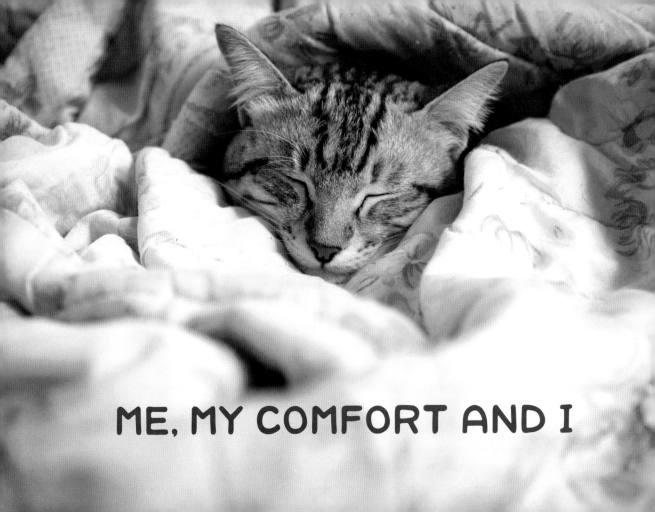

ME, MY COMFORT AND I

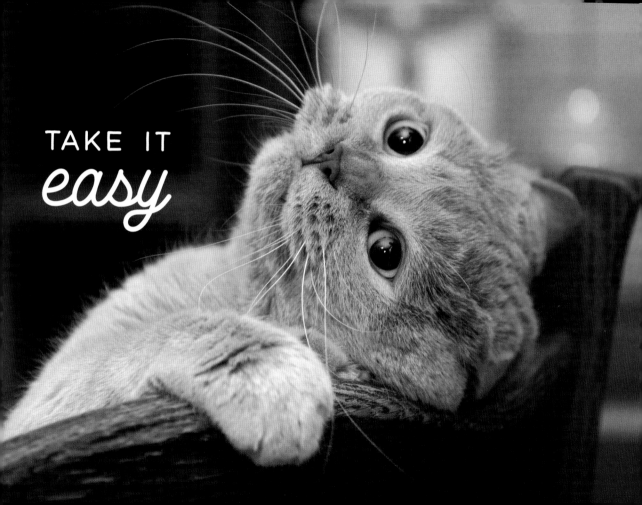

SOMETIMES THE MOST
IMPORTANT THING IN
A WHOLE DAY IS THE
REST WE TAKE BETWEEN
TWO DEEP BREATHS.

ETTY HILLESUM

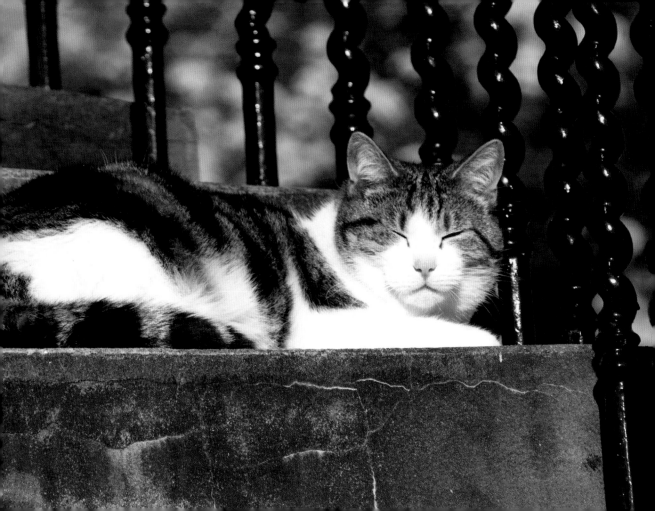

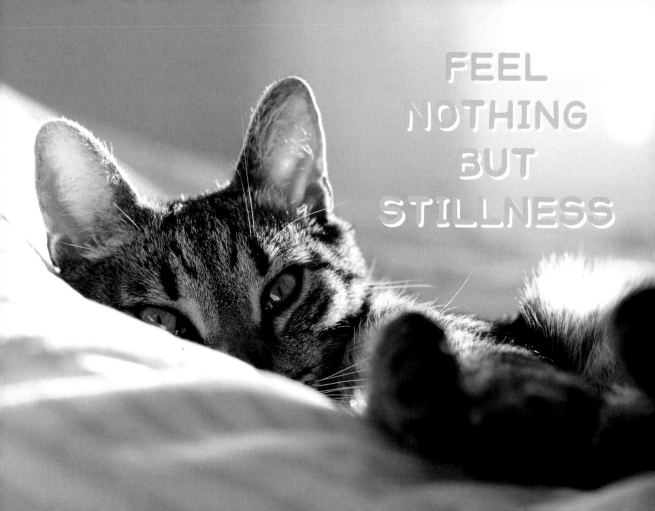

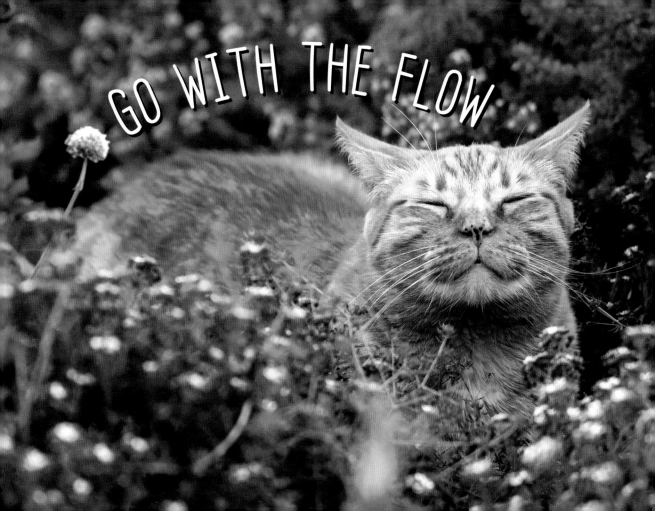

GO WITH THE FLOW

WHEN IT COMES TO
KNOWING HOW TO RELAX,
CATS ARE THE ORIGINAL
yoga experts.

PATRICIA CURTIS

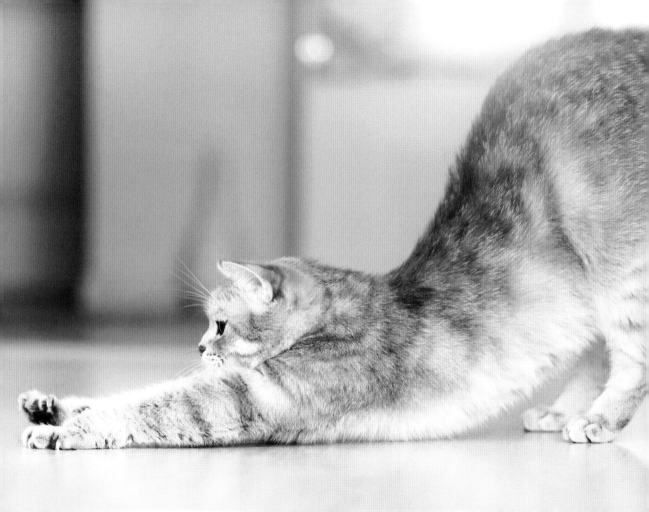

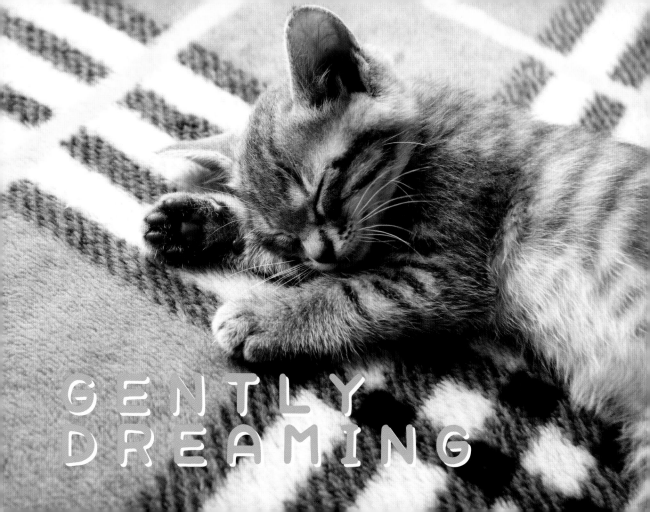

I AM HERE...

... and now

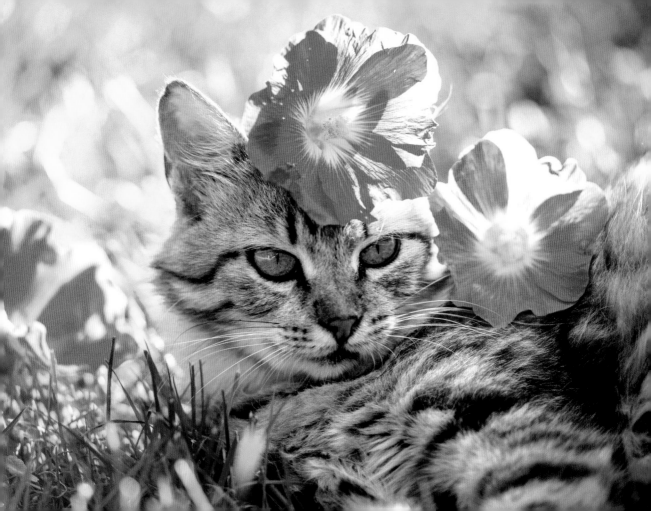

DON'T HURRY, DON'T WORRY.
And be sure to
SMELL THE FLOWERS
along the way.

WALTER HAGEN

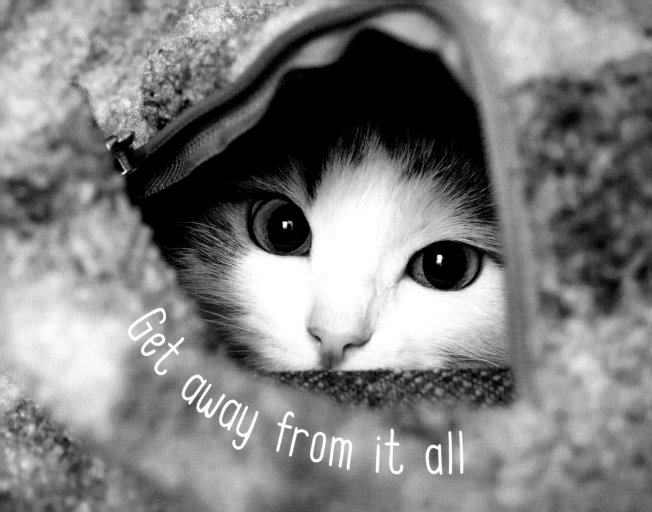

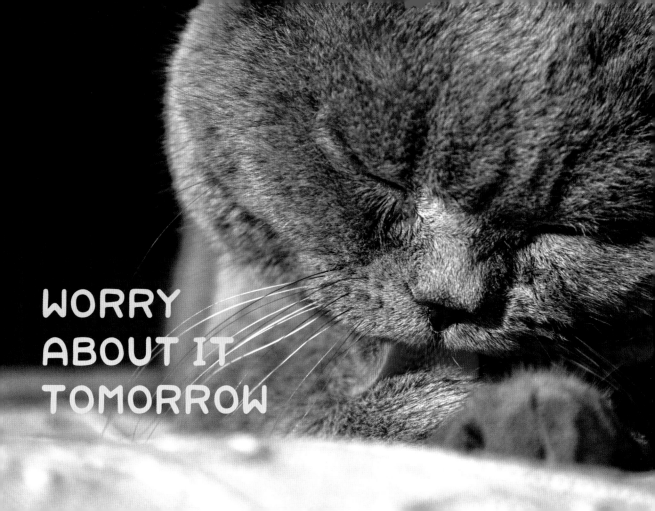

BE HAPPY FOR
THIS MOMENT.
THIS MOMENT
IS YOUR LIFE.

OMAR KHAYYAM

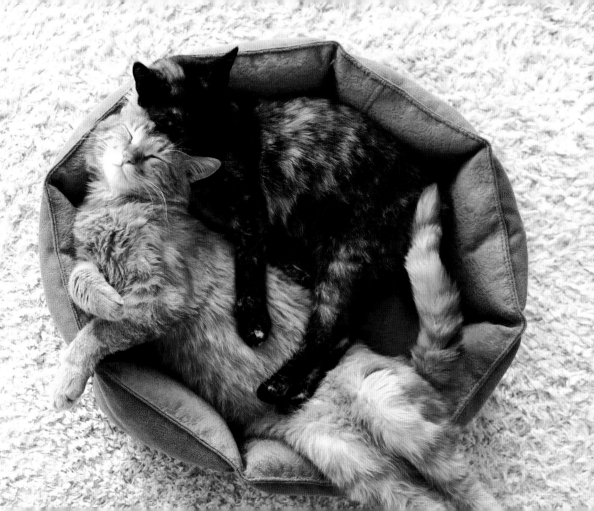

I HAVE A PEACEFUL MIND

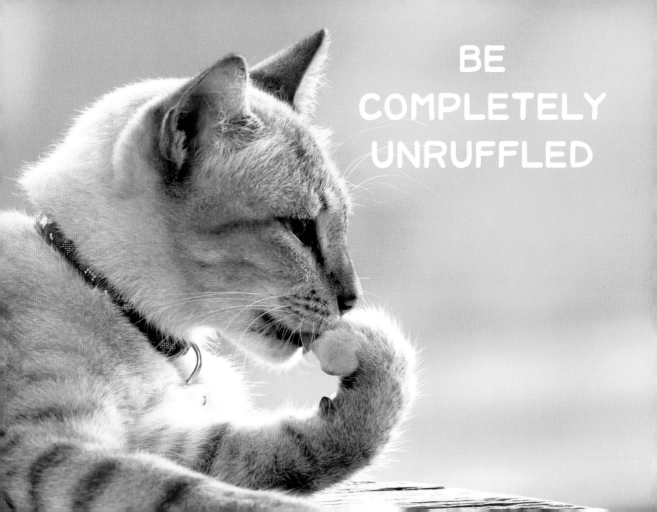

CARVE OUT

and claim the time to

CARE FOR YOURSELF

and kindle your own fire.

AMY IPPOLITI

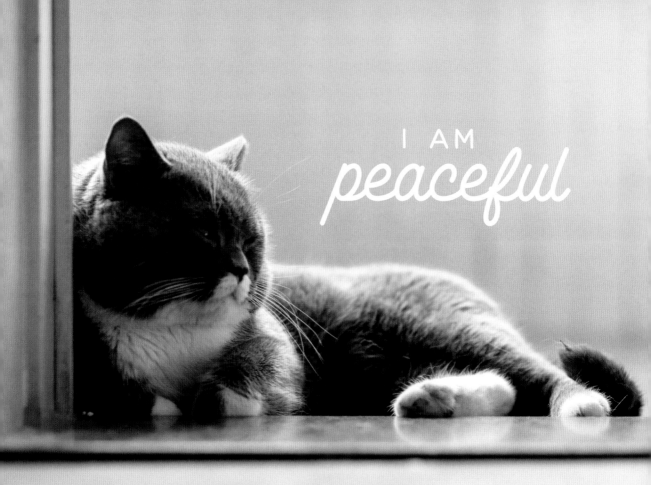

I AM
peaceful

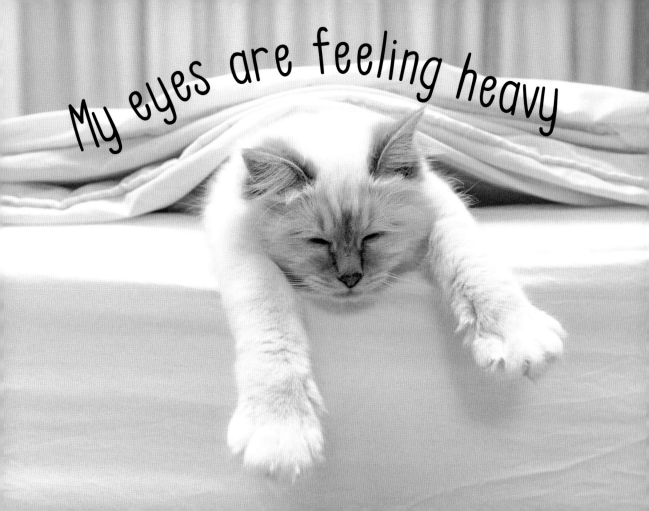

A LITTLE DROWSING CAT IS AN IMAGE OF PERFECT BEATITUDE.

CHAMPFLEURY

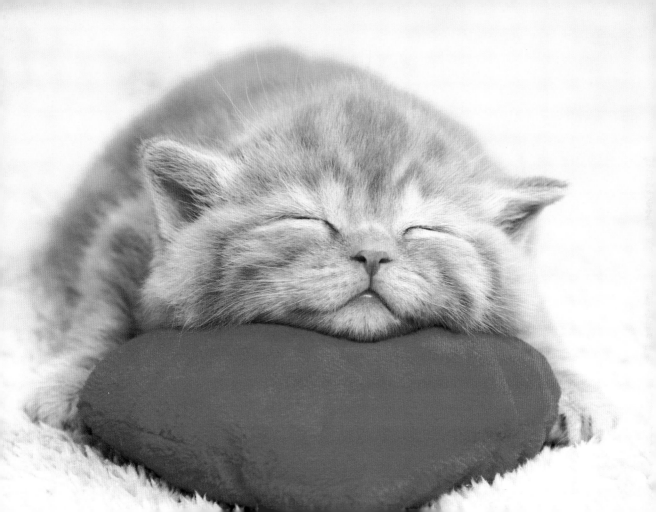

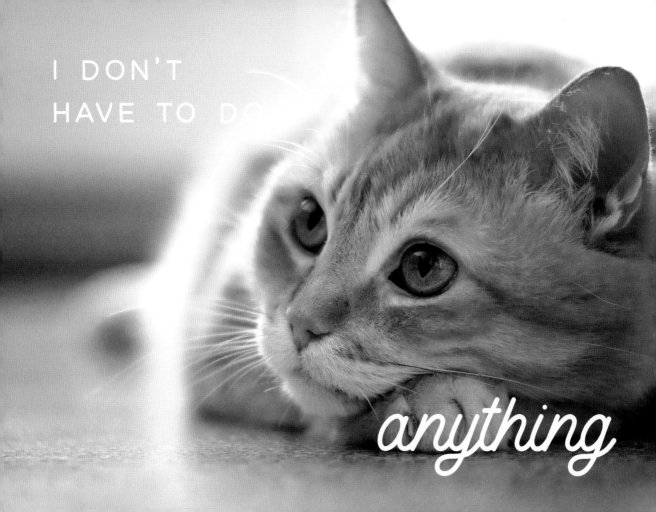

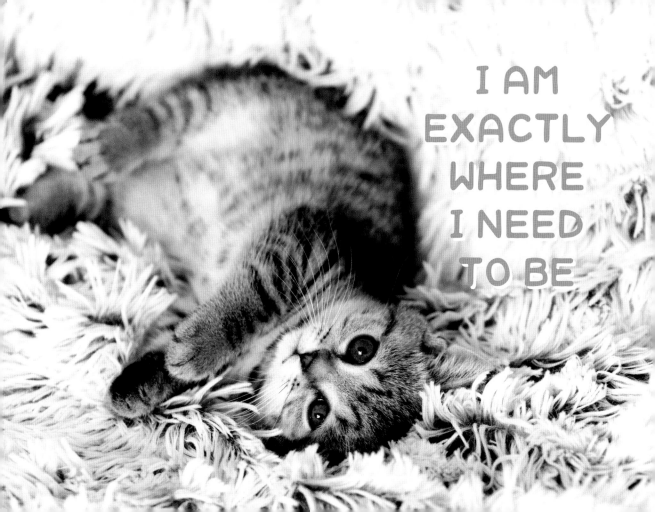

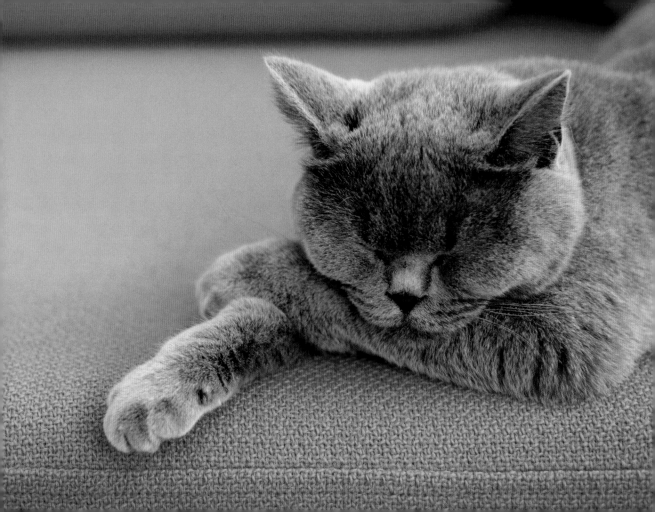

LEARN TO BE CALM
AND YOU WILL

always be happy.

PARAMAHANSA YOGANANDA

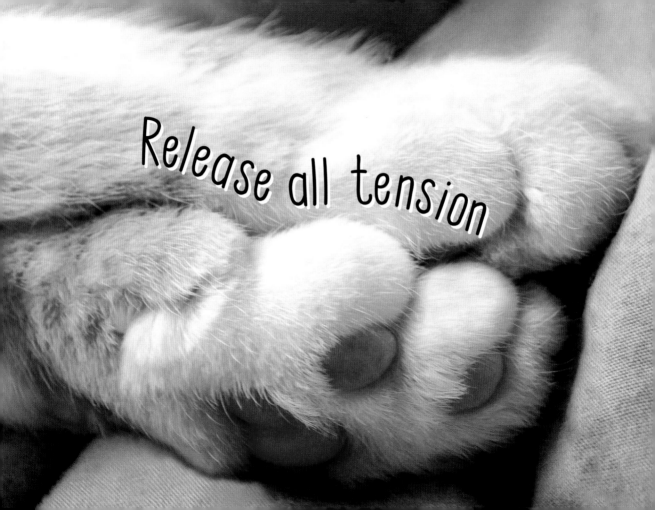

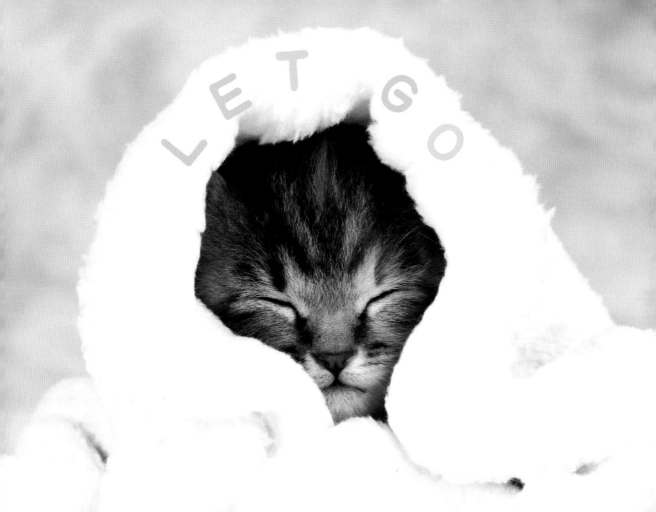

Adopt the pace of nature:
HER SECRET IS PATIENCE.

RALPH WALDO EMERSON

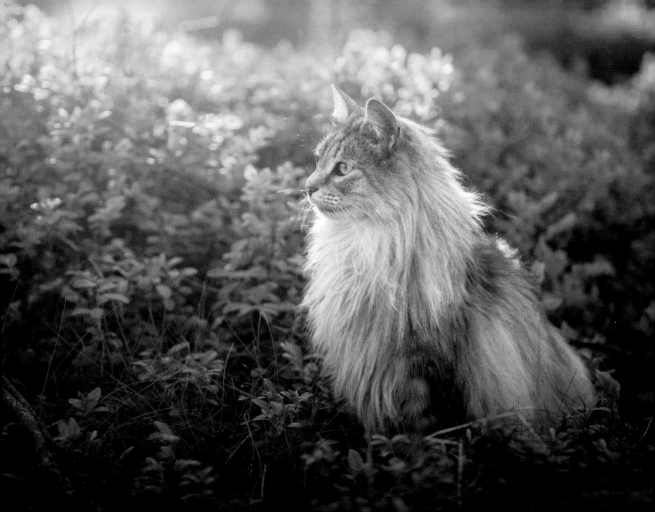

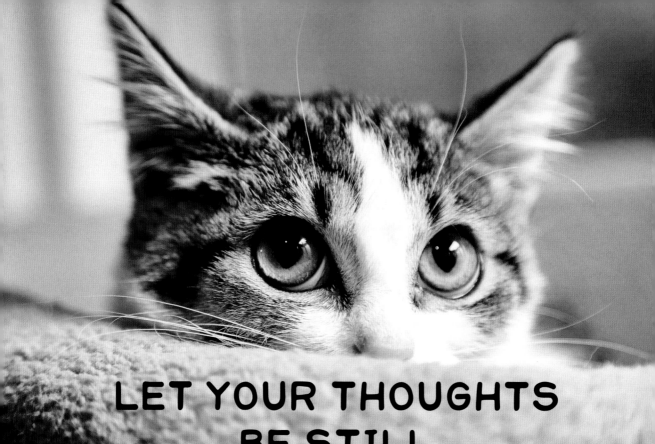

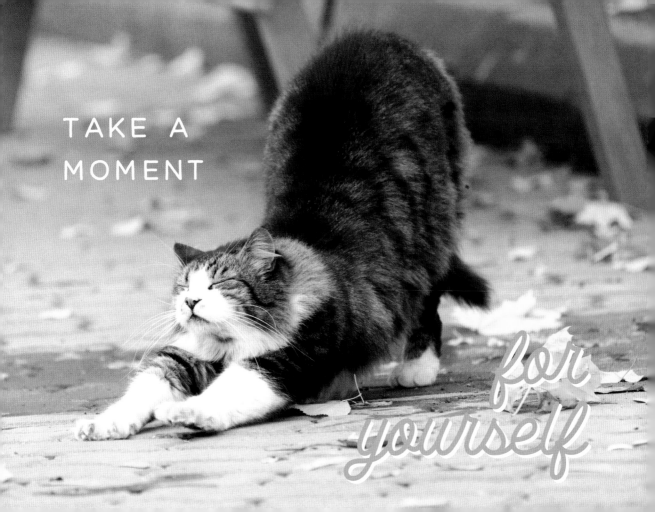

TAKE A MOMENT

for yourself

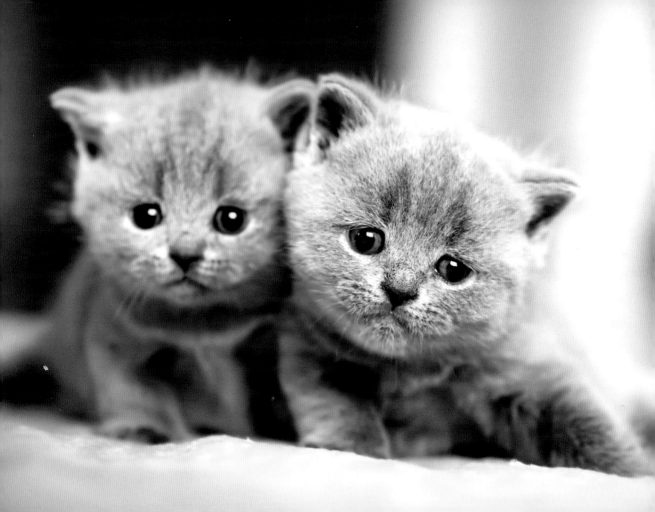

THERE ARE FEW THINGS
IN LIFE MORE HEART-
WARMING THAN TO BE
WELCOMED BY A CAT.

TAY HOHOFF

PERFECT TRANQUILLITY

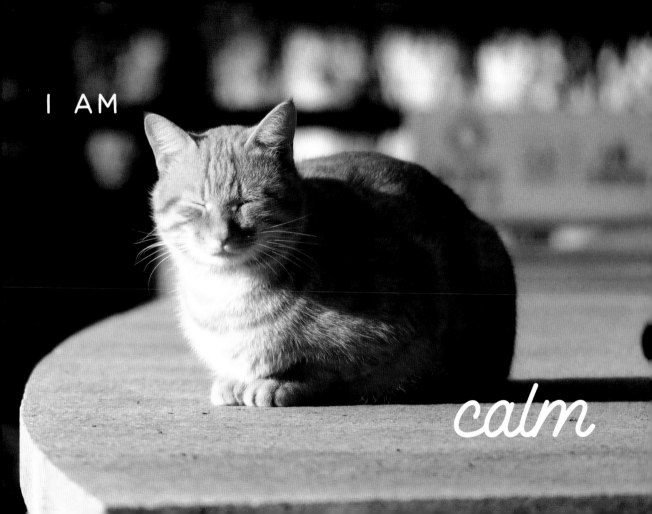

I AM

calm

NOTHING MAKES A HOUSE COSIER THAN CATS.

GLADYS TABER

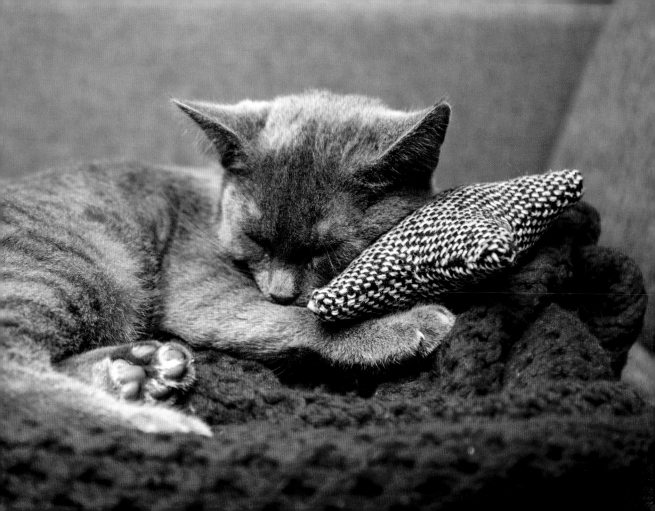

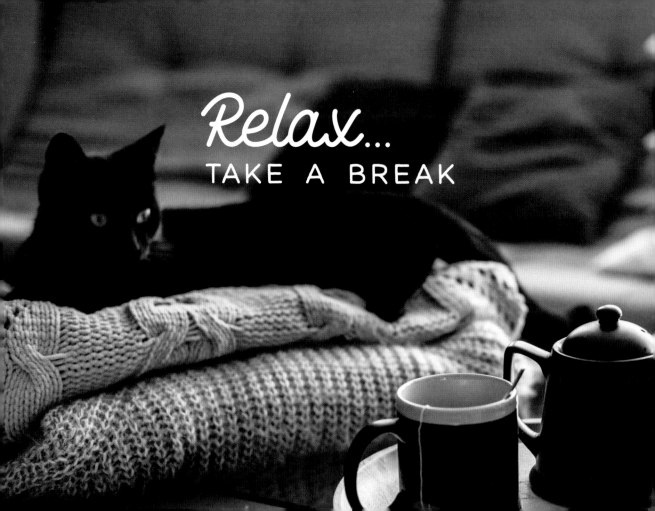

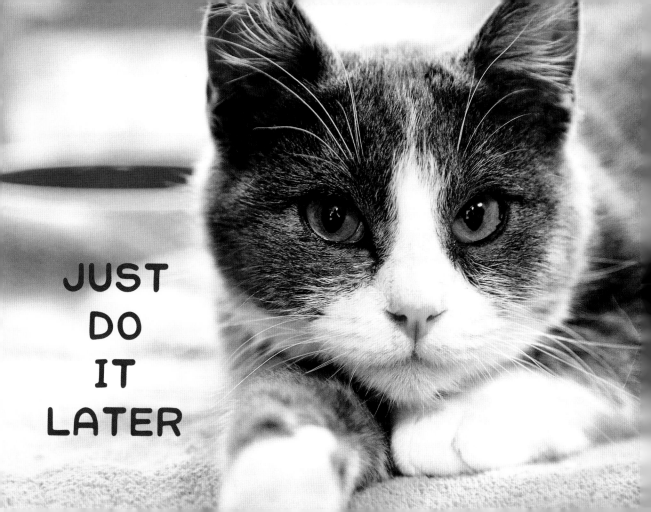

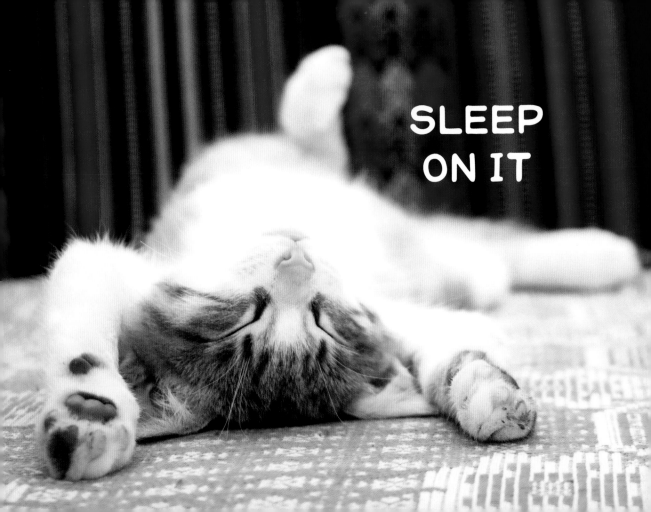

SLEEP
ON IT

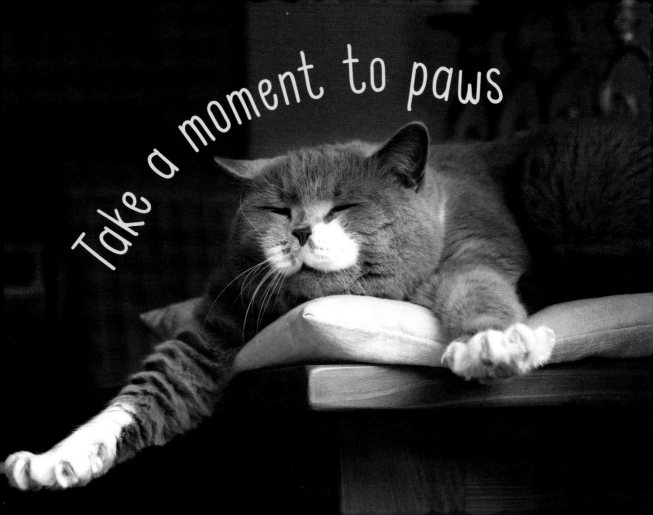

Image credits

If you're interested in finding out more about our books,
find us on Facebook at Summersdale Publishers and
follow us on Twitter at @Summersdale.

www.summersdale.com